The California Poppy
Miracle of Spring

BY
KAY HENDRICKSON

Dedication

I dedicate this collection of my photographs to...
My father who started me on a lifelong hobby of photography.
My mother who found such pleasure and joy in the Antelope Valley wildflowers.
My husband who has always supported my love of photography,
encouraged my creativity and cheered my success.
My sister who created the unique poetry for my photographs and has been a best friend
and mentor throughout my life.
My children and grandchildren who continually bring me joy.

PUBLISHED BY POWERSURGE PUBLISHING
Scottsdale, Arizona

ISBN: 1-890457-14-0
Copyright © 2004 by Kay Hendrickson
"First printing: April 2004"
All rights reserved.

ALL PHOTOGRAPHY BY KAY HENDRICKSON

Design and digital production by **Christine Kline**
Printed by **Ventura Printing**, Oxnard, California

This book and images from this book are available by visiting
The California Poppy Miracle of Spring website at:
www.photokay.com
The publisher may also be contacted for information regarding this publication.

PowerSurge
PUBLISHING

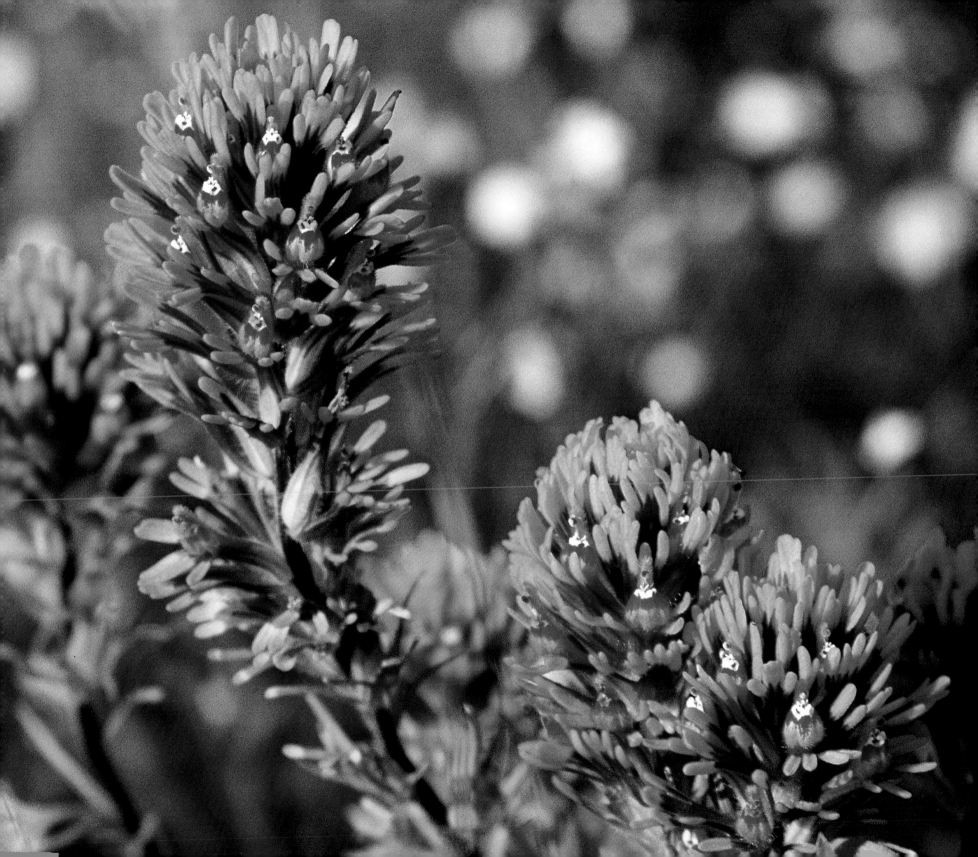

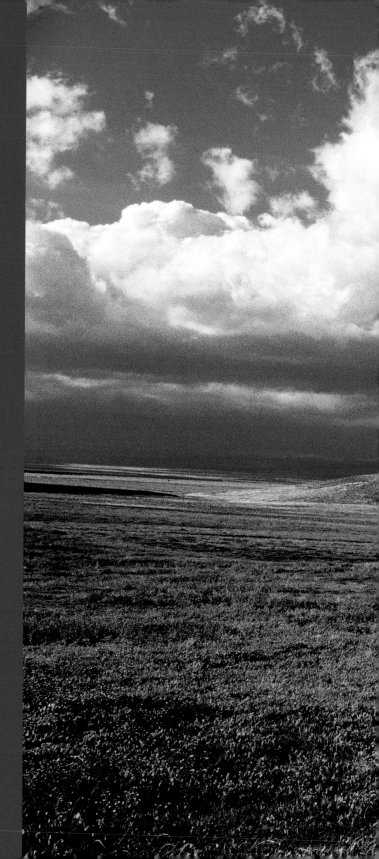

Introduction

Spring on the Mojave Desert is a time of rebirth. The correct amount of cold weather, rain and sunshine will germinate a multitude of poppy and other wildflower seeds. The hills and desert floor come alive with hues of orange, yellow and purple, creating a multi-colored carpet of flowers and green grasses.

Even after many years of living in the Antelope Valley, I anticipate with great excitement the prospect of the wildflower season. To me it *is* a miracle of spring. To see, to photograph, to experience the magnificence of the flowers is a gift from Mother Nature, intended to nurture our souls and renew our spirits. Capturing these scenes on film has been my enduring passion.

With my photographs, I want to share with you the breathtaking beauty that I have experienced. Join me on this journey, take your time and return often. *Take it in...it is all yours.*

Kay Hendrickson

Antelope Valley California Poppy Reserve

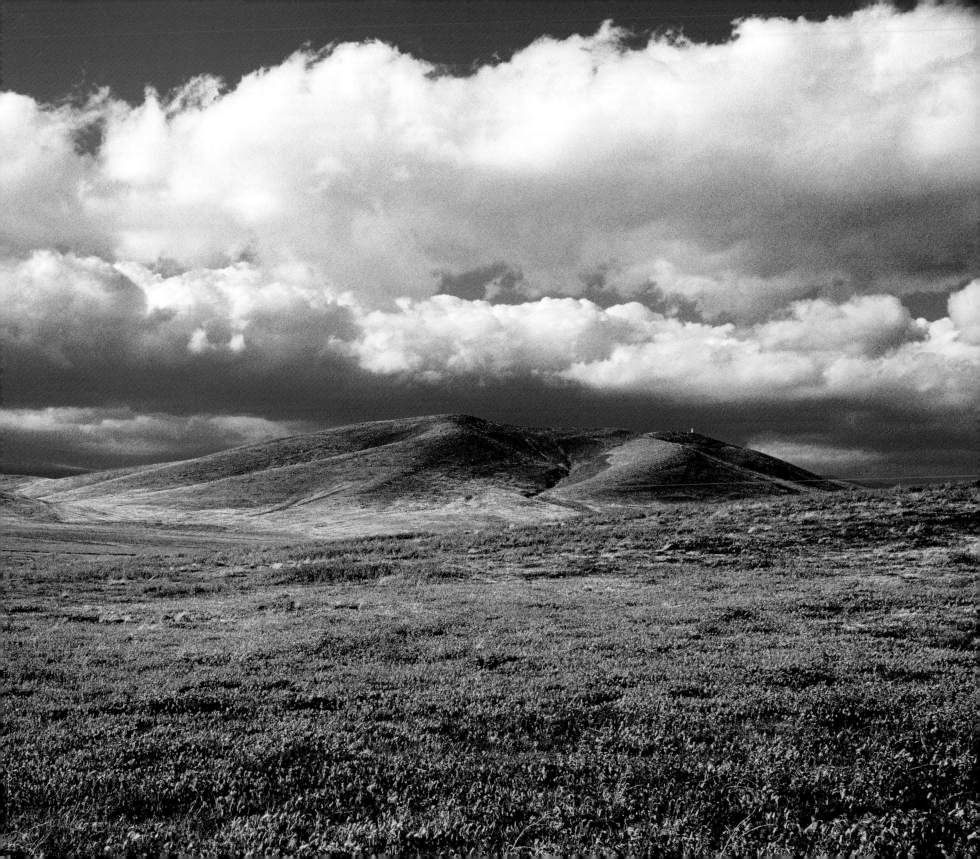

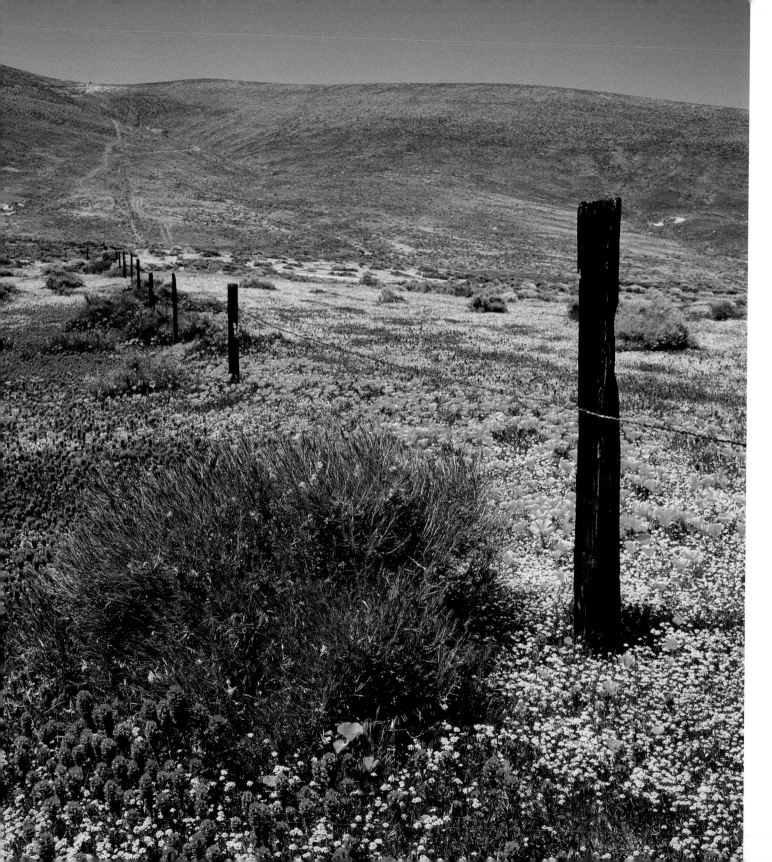

Don't Fence Me In

Old brown fence posts sitting
Amid the fields of gold
Remnants of a story
A past for now untold!

Patricia Swanson

California Quail

Busy! Busy! Busy!
Scratching on the ground.
Beautiful plump quail
Bustling all around.
Running here and running there
Alert to finding feed
Under trees and bushes
Looking for some seed.
California Quail,
Such fun to be around,
A black and curling plume
On every bird is found.

Patricia Swanson

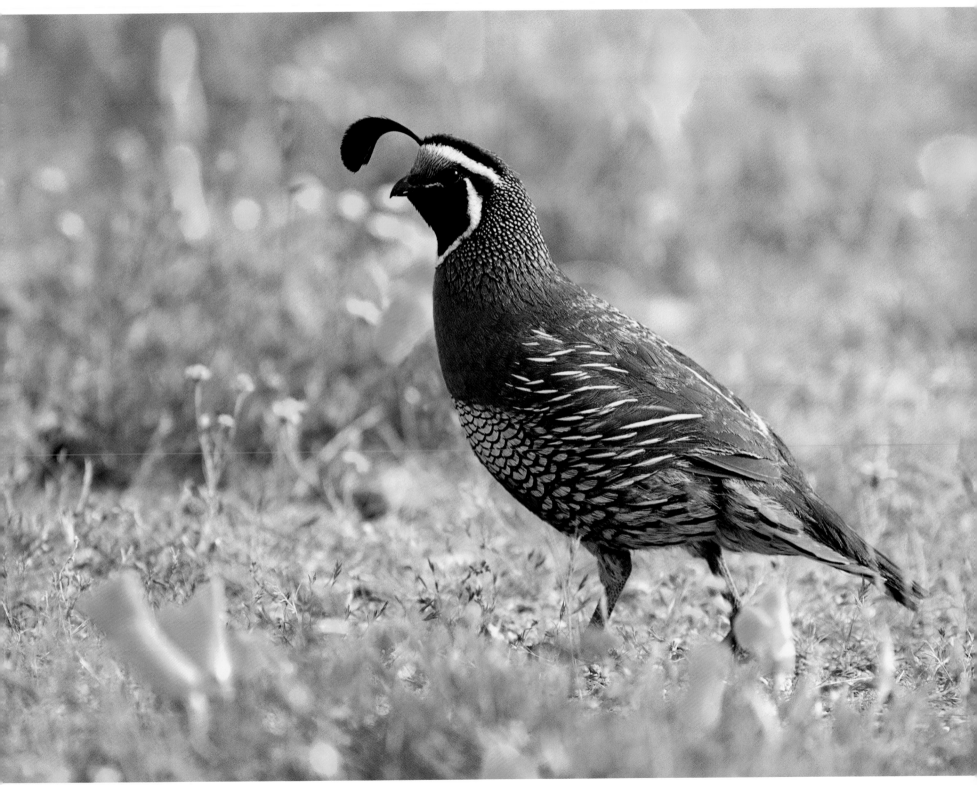

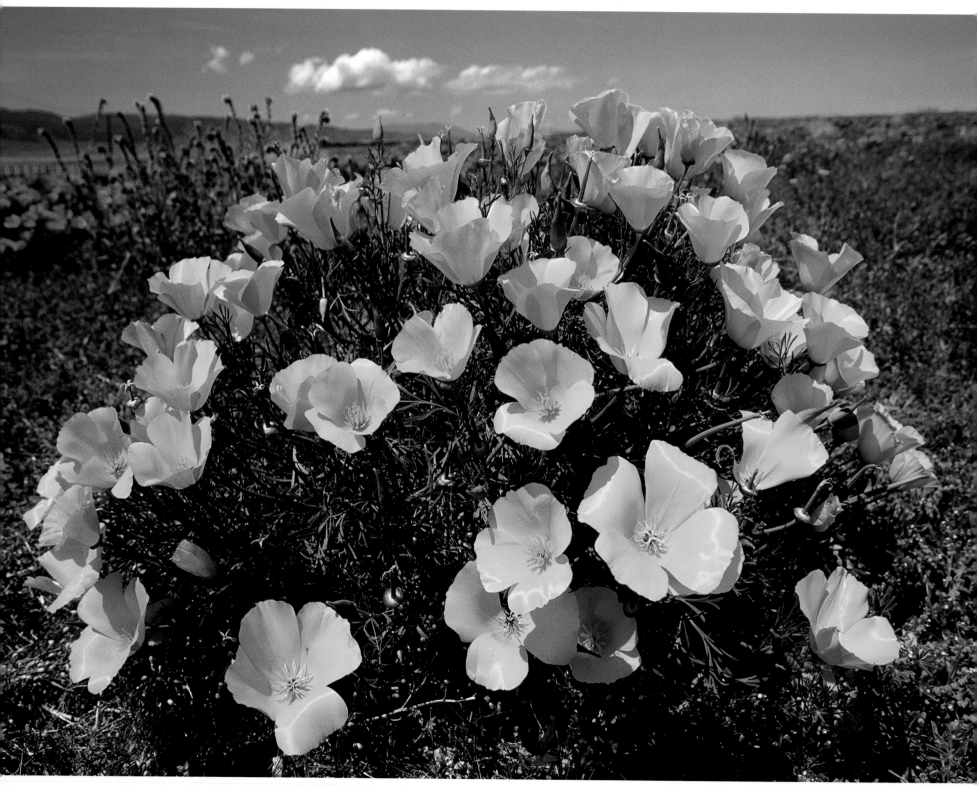

Lemon Trumpet Flower

Yellow Bush Poppy

Creation's beauty awesome
The desert blossoms fair
A valley filled with flowers
A springtime view that's rare.

Patricia Swanson

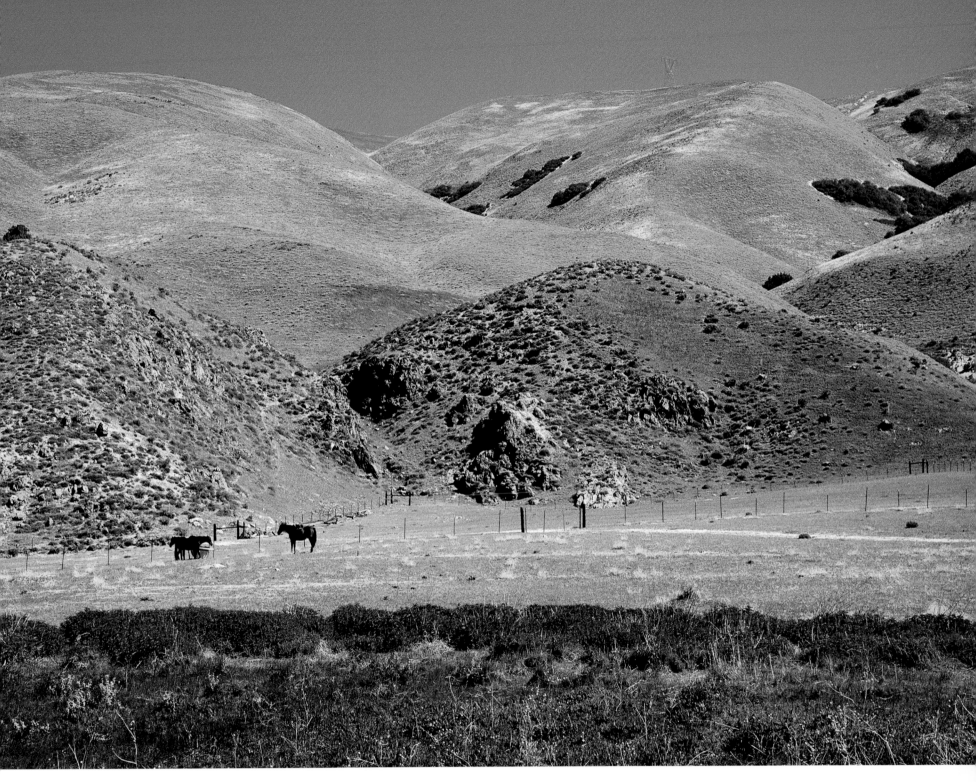

Lush Green Pastures

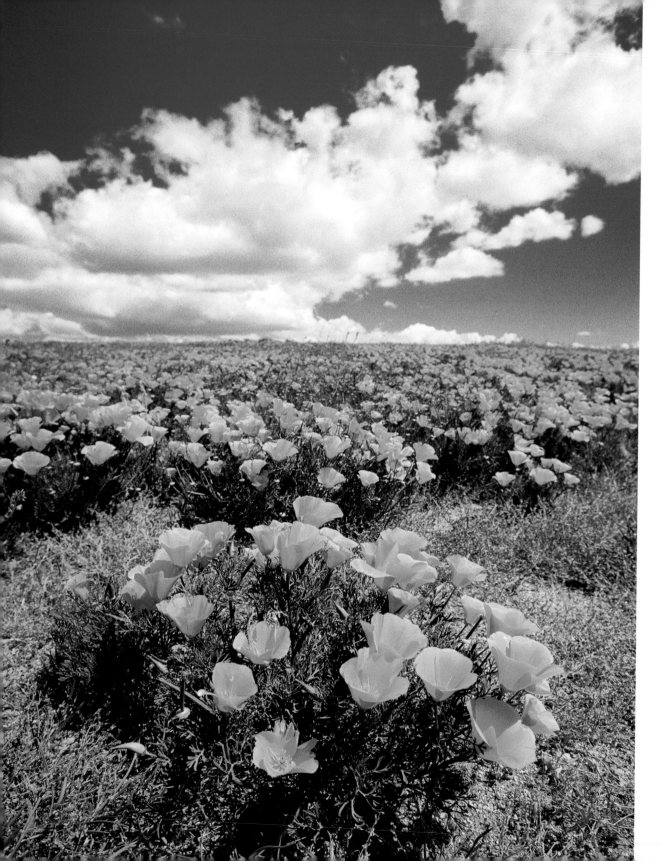

White Clouds

Gazing upward. Skies of blue
White clouds moving give a clue
To shapes and sizes large and small
As winds blow and change them all
Creating pictures in the mind
Whatever image you can find.
Days long past in youthful dreams
Memories come–on those beams
Of light and youth spent on the grass
Imagination–time will pass
Gazing upward toward the sky
Pondering questions how and why
Those fluffy clouds are moving by
Wishing that this time would last
As those clouds are moving past.
Age can change the body round
But wishful thoughts are still around.

Patricia Swanson

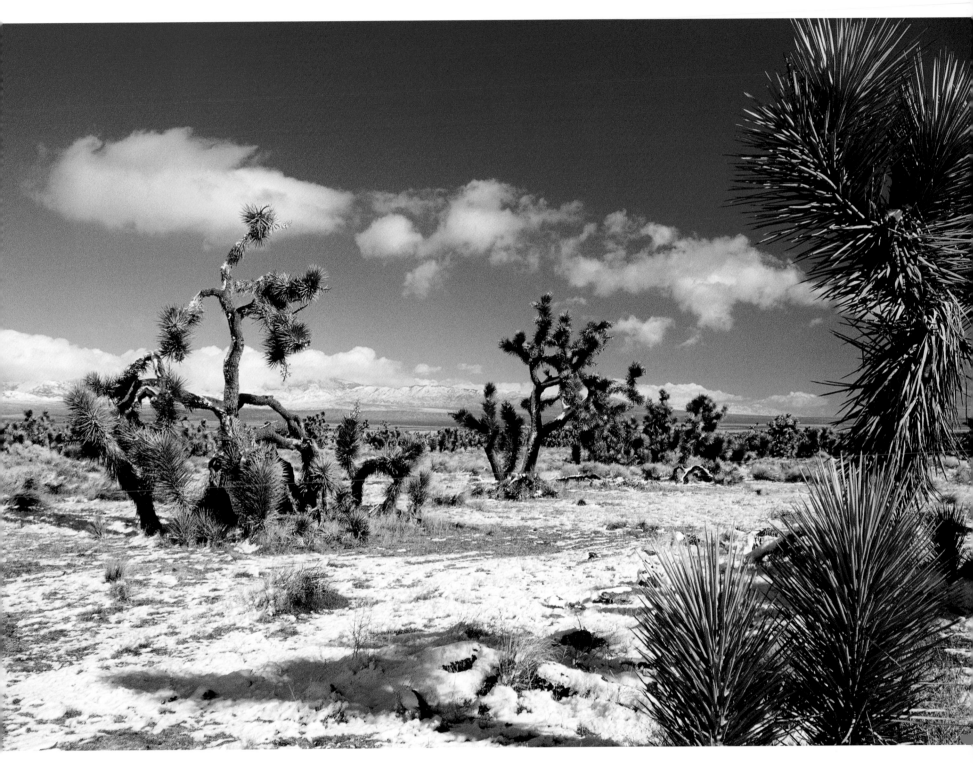

Joshuas in Winter

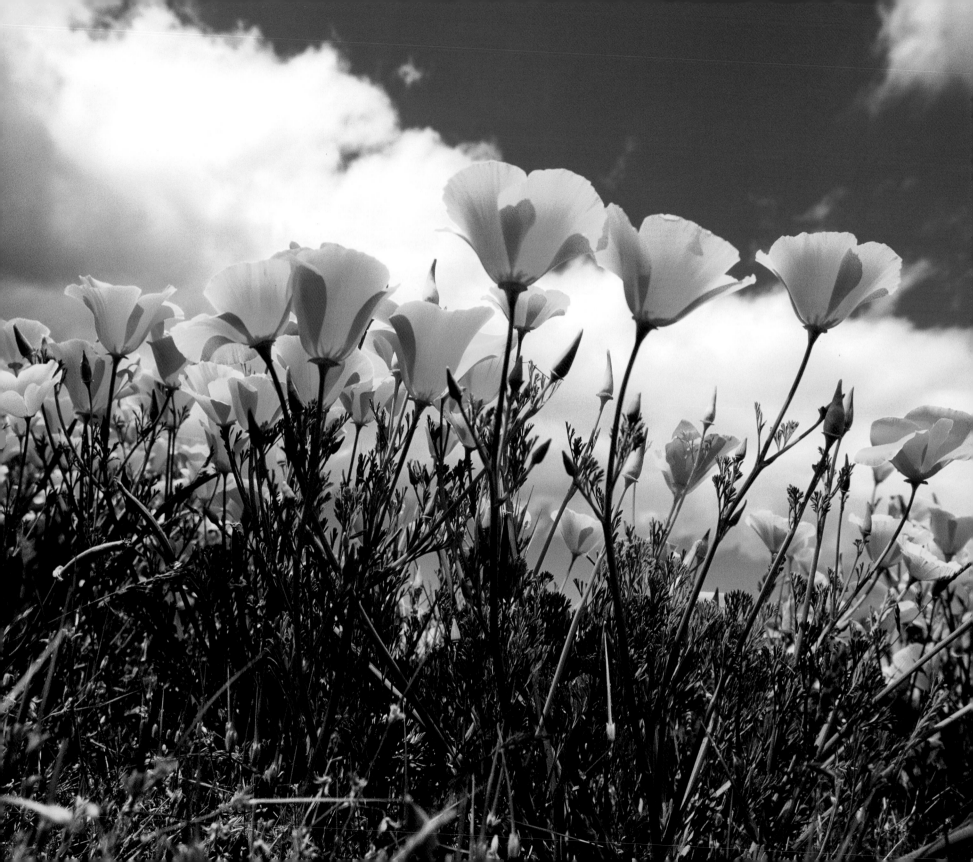

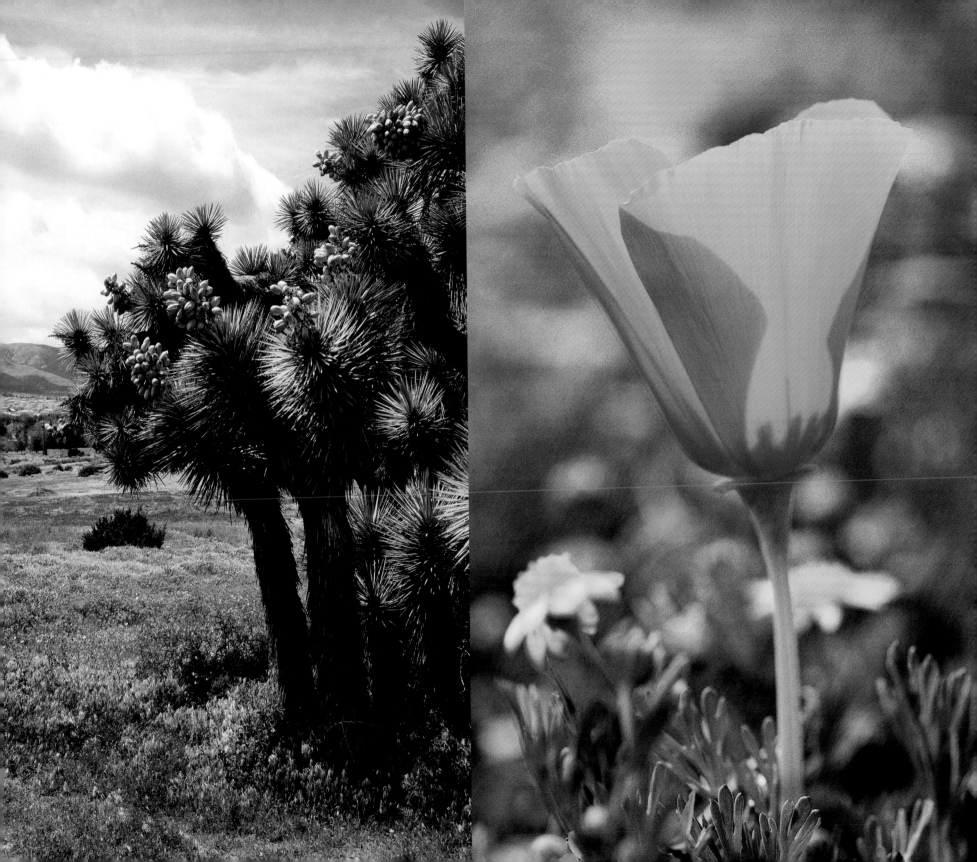

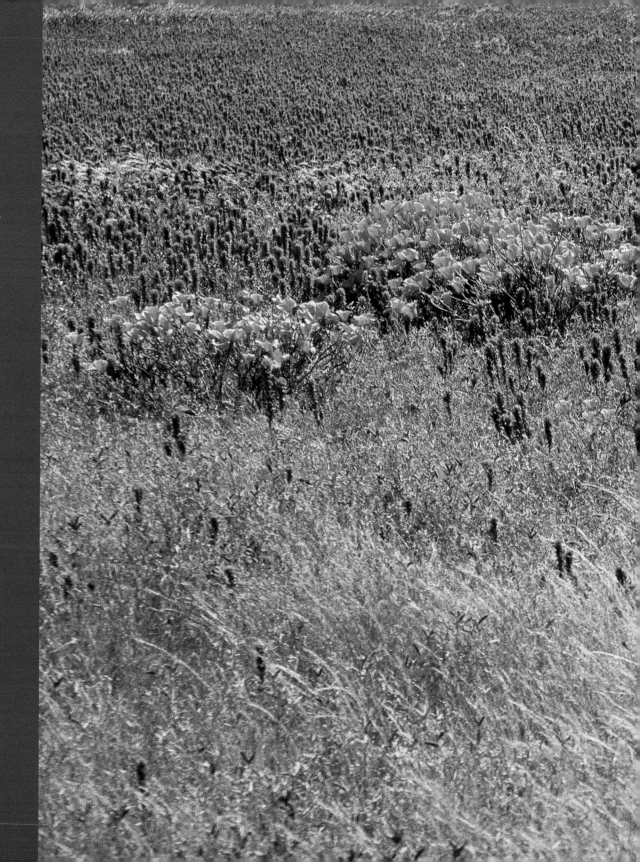

Owl's Clover & Poppies

Weather blows the wind
Upon a field so bright
Flower petals sparkle
And beckon with delight.

Patricia Swanson

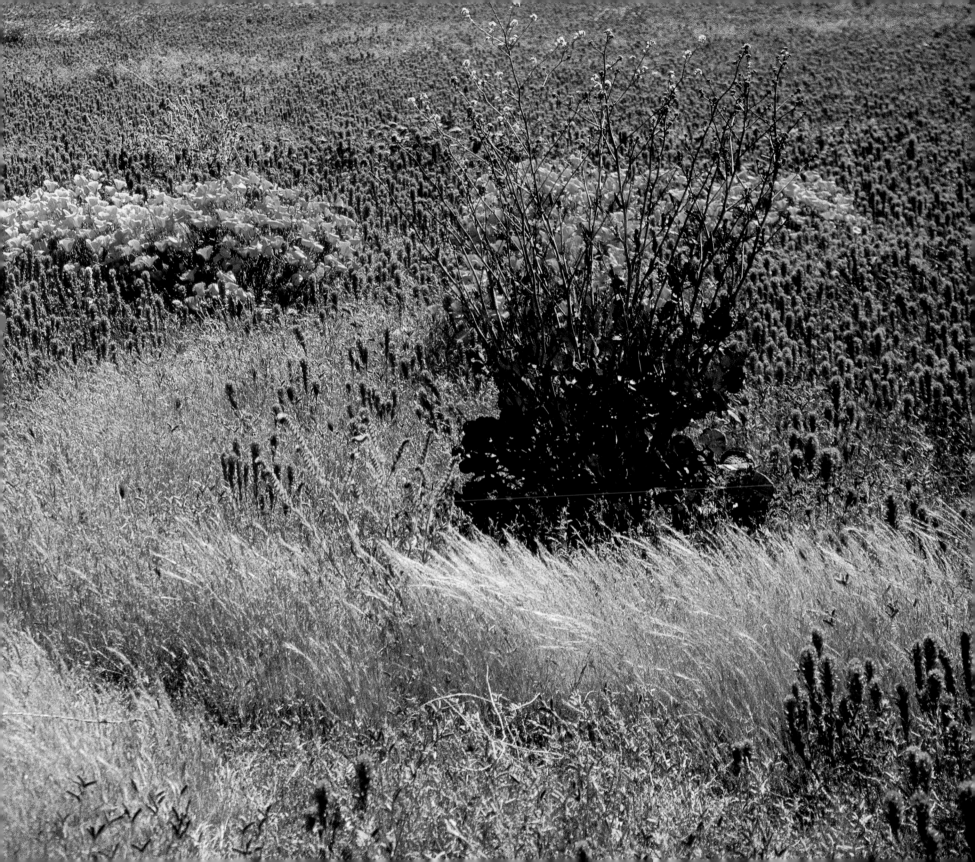

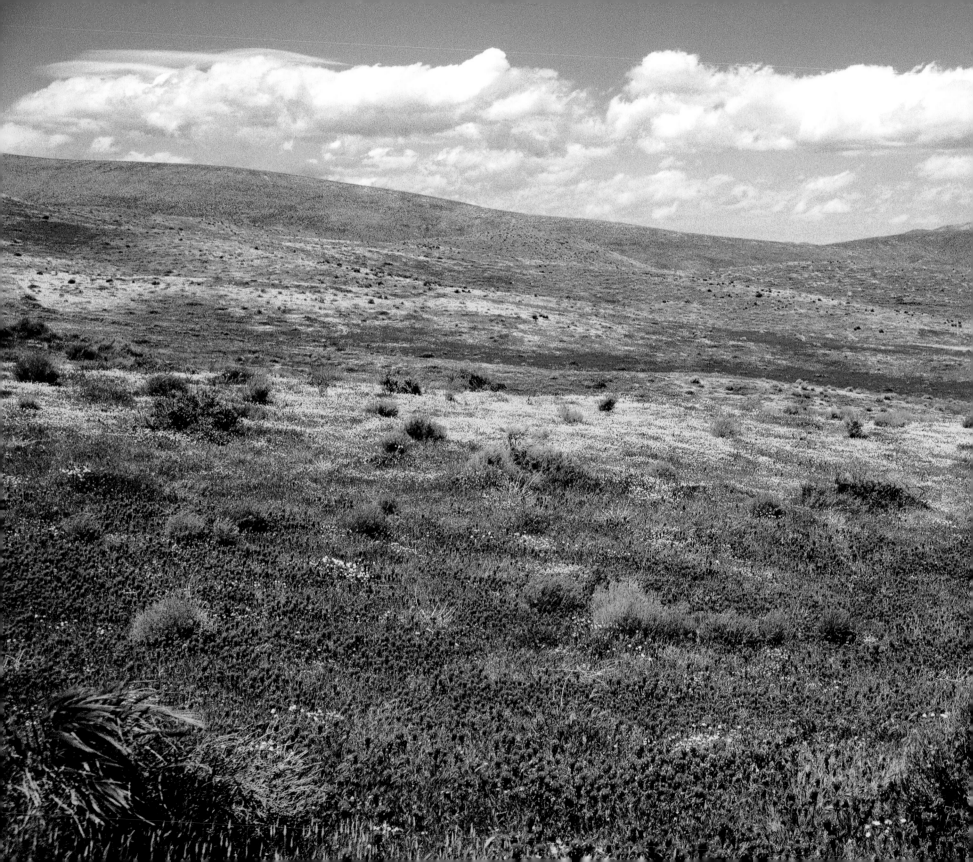

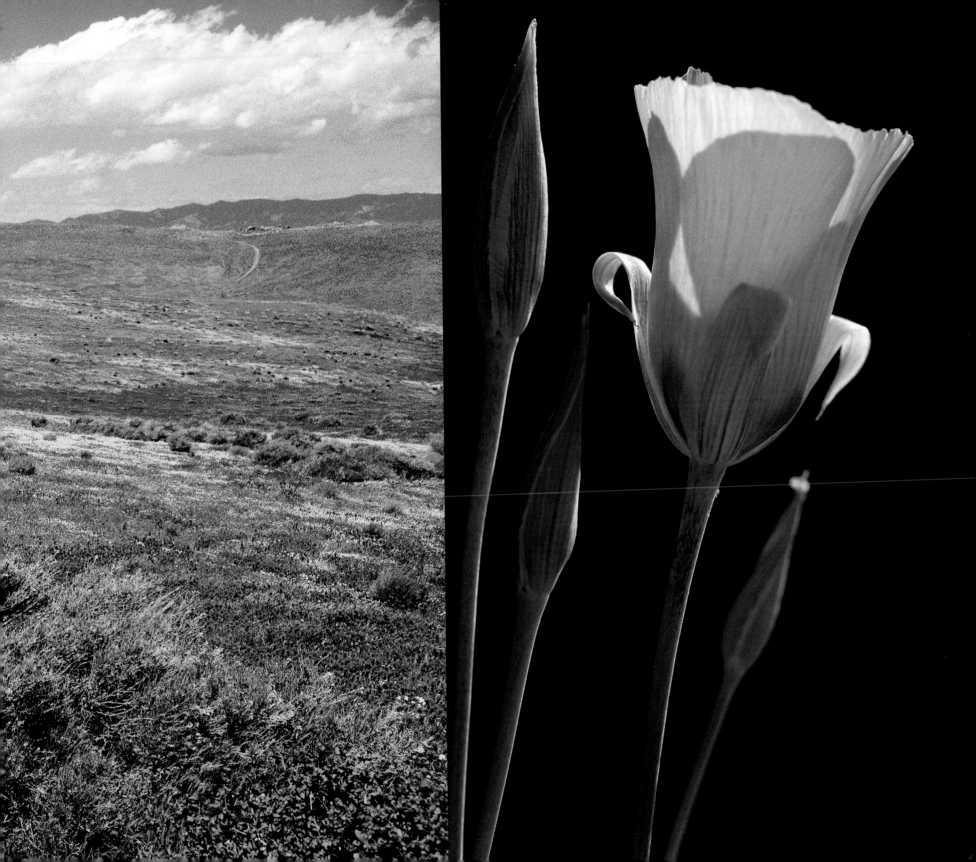

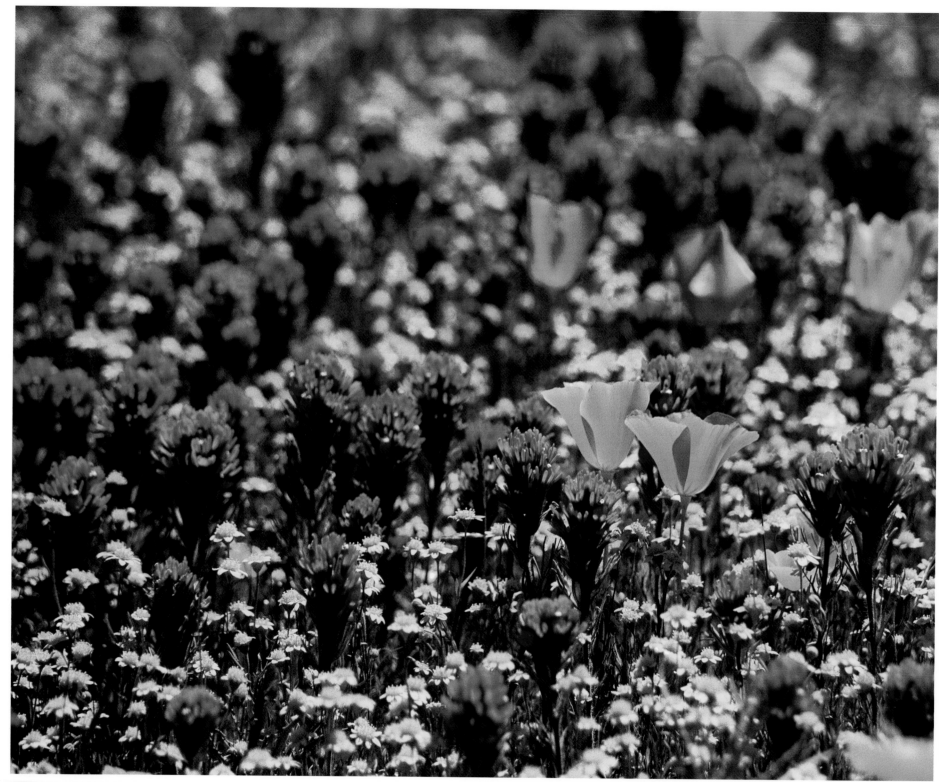

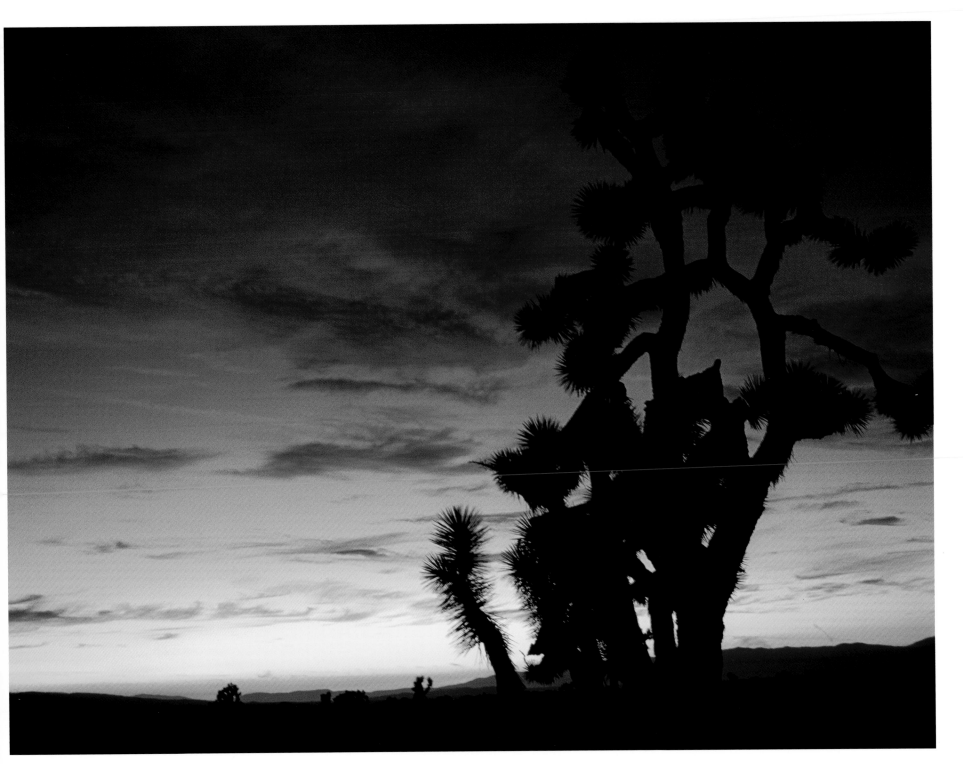

Morning Light

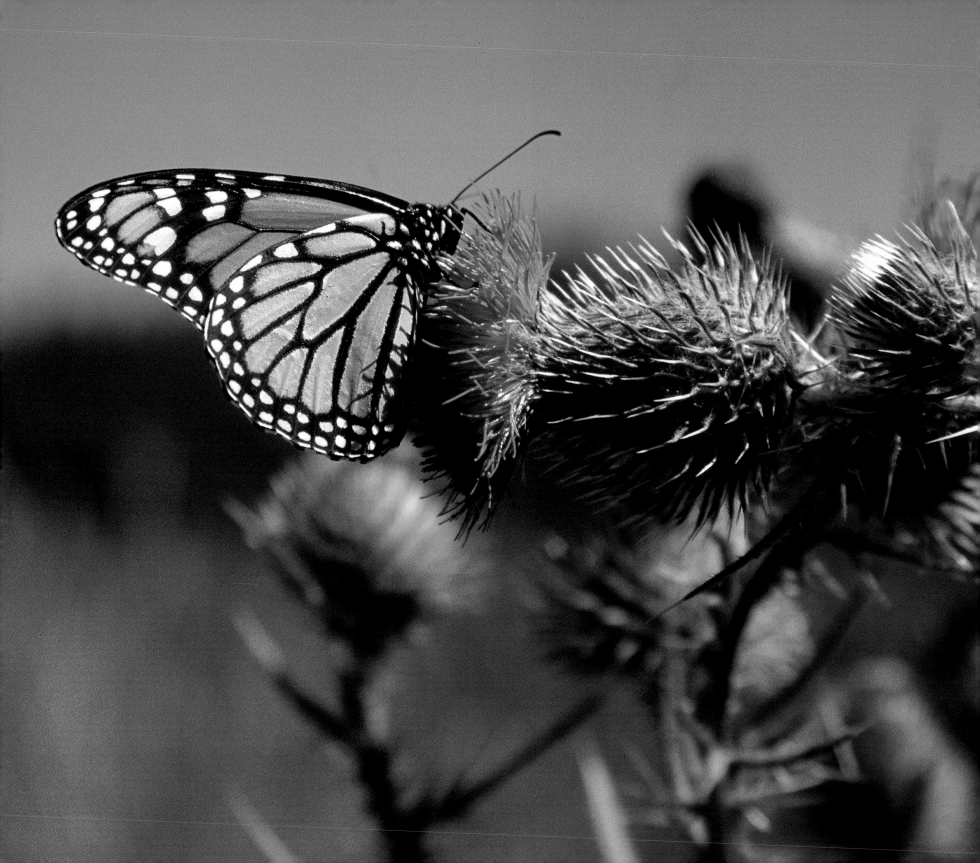

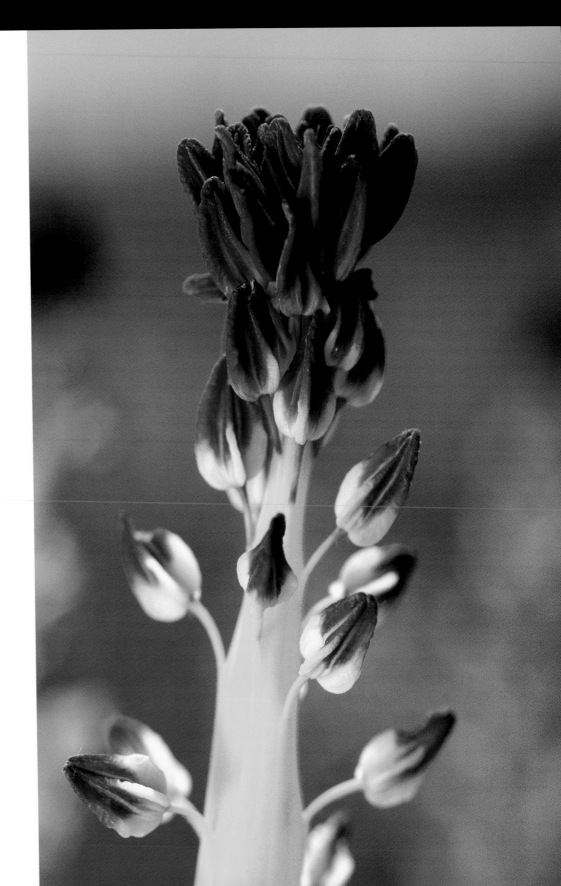

Monarch Butterfly on Mojave Thistle

The Monarch so beautiful flies in the Spring
She has a long journey with rebirth to bring
Her wings are so lovely, the colors divine
When she flies near, I wish she were mine
She rests on the thistle, to sip the sweet juice
And when warm and nurtured, she's off on the loose
Completing her journey with each passing day
I'm thankful she stopped, while going this way.

Kay Hendrickson

Desert Candle

Standing lone and silent like a sentinal on guard
A tall and gold stalked flower blooms in our backyard
A royal busby on its head this soldier of the field
Rank by rank advances to meet the poppies yield
The opal mountains standing tall
Greet the Desert Candle spring to fall
Though this candle gives no light
It's purple hue is heart's delight.

Roderic MacDuff

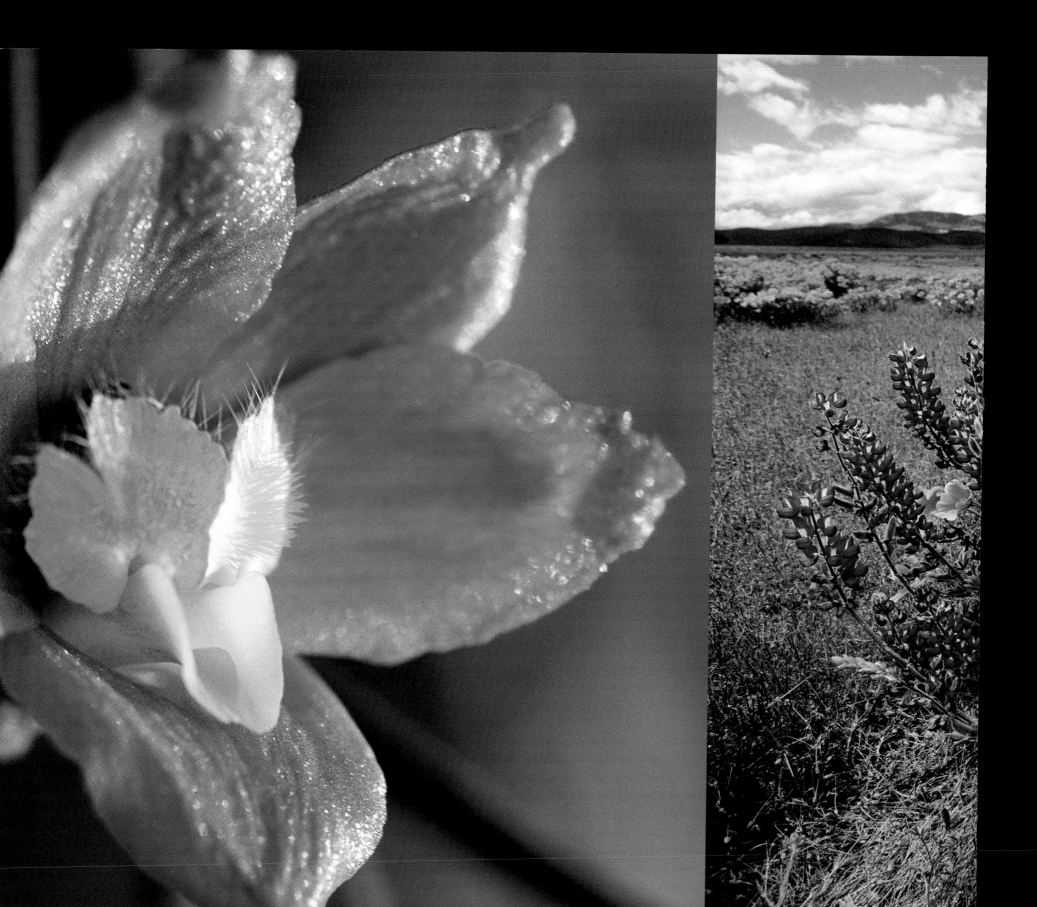

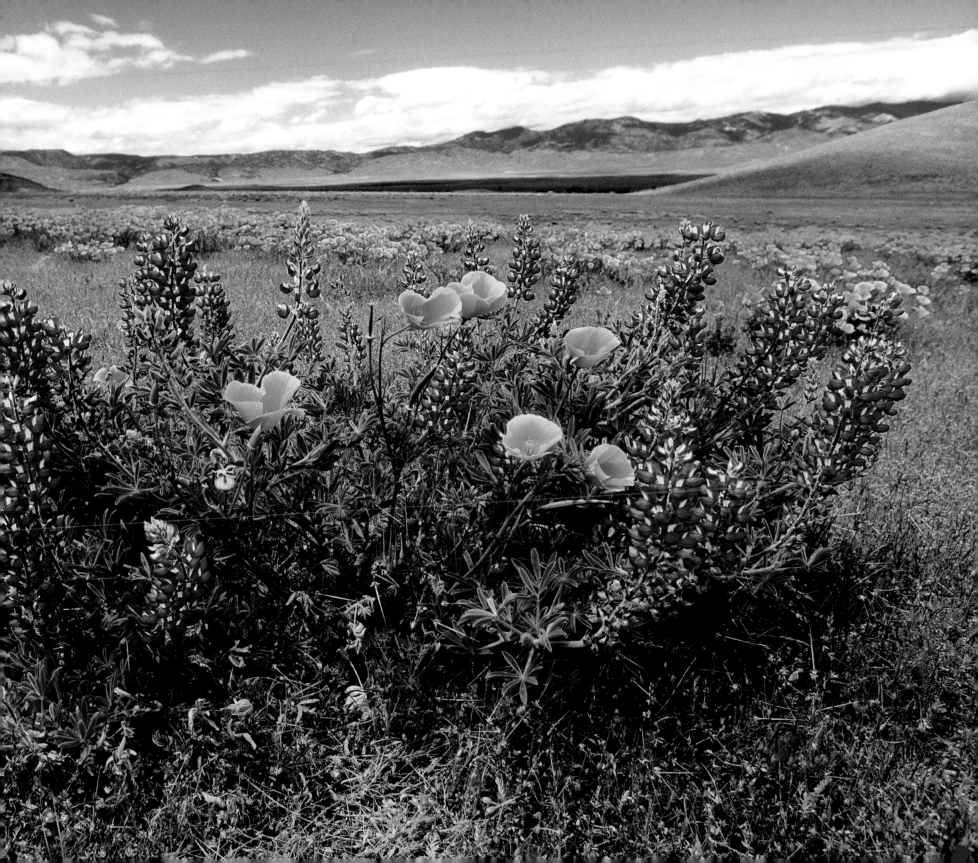

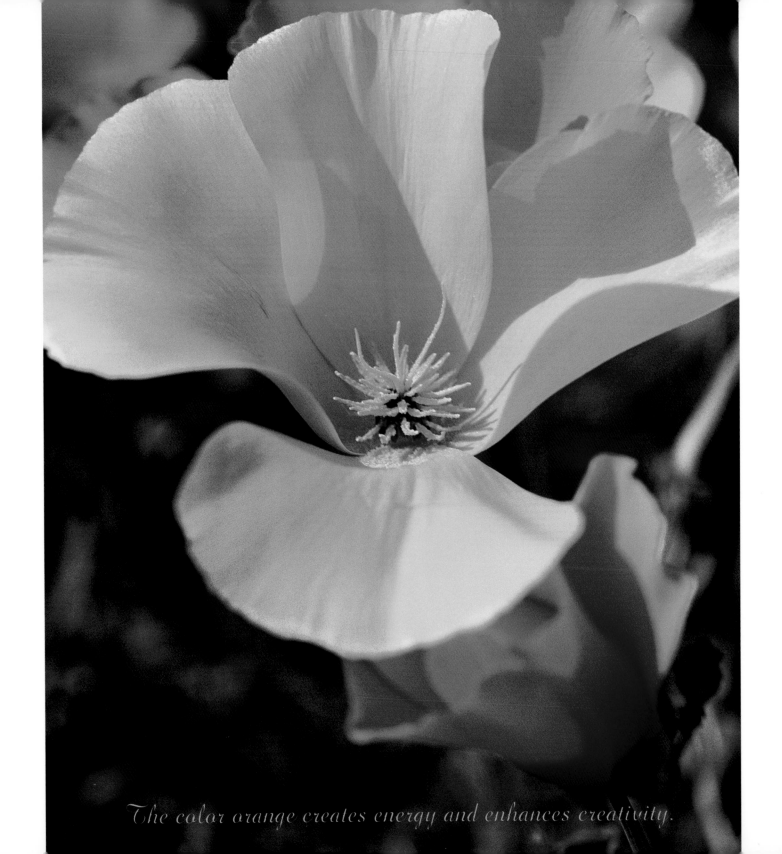

The color orange creates energy and enhances creativity.

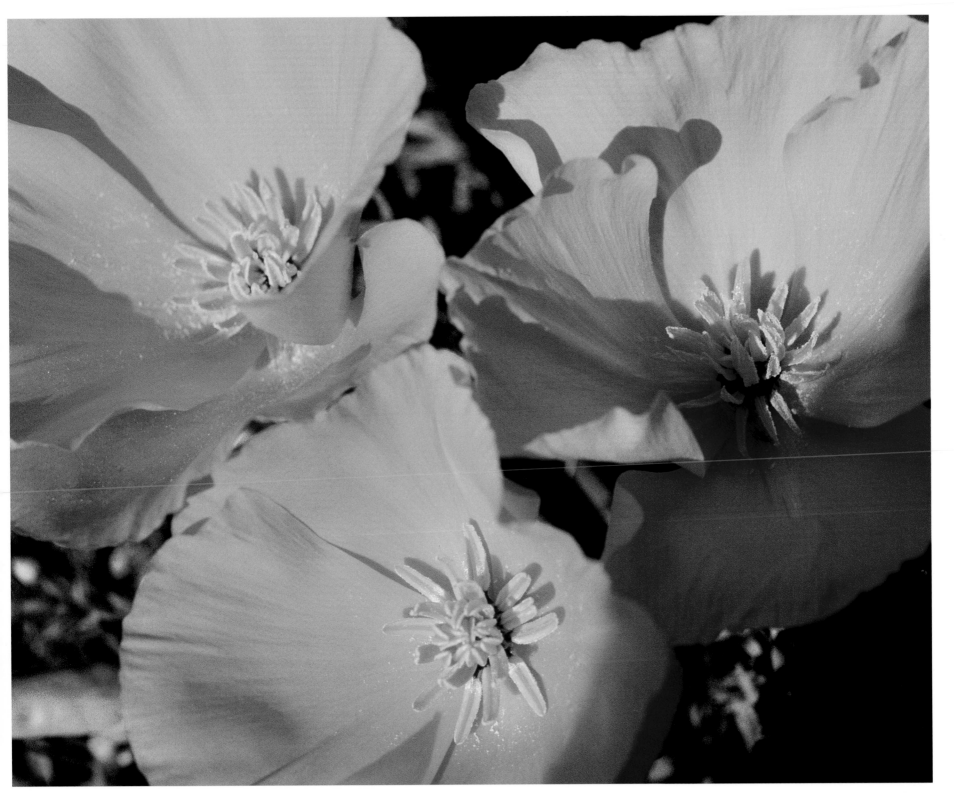

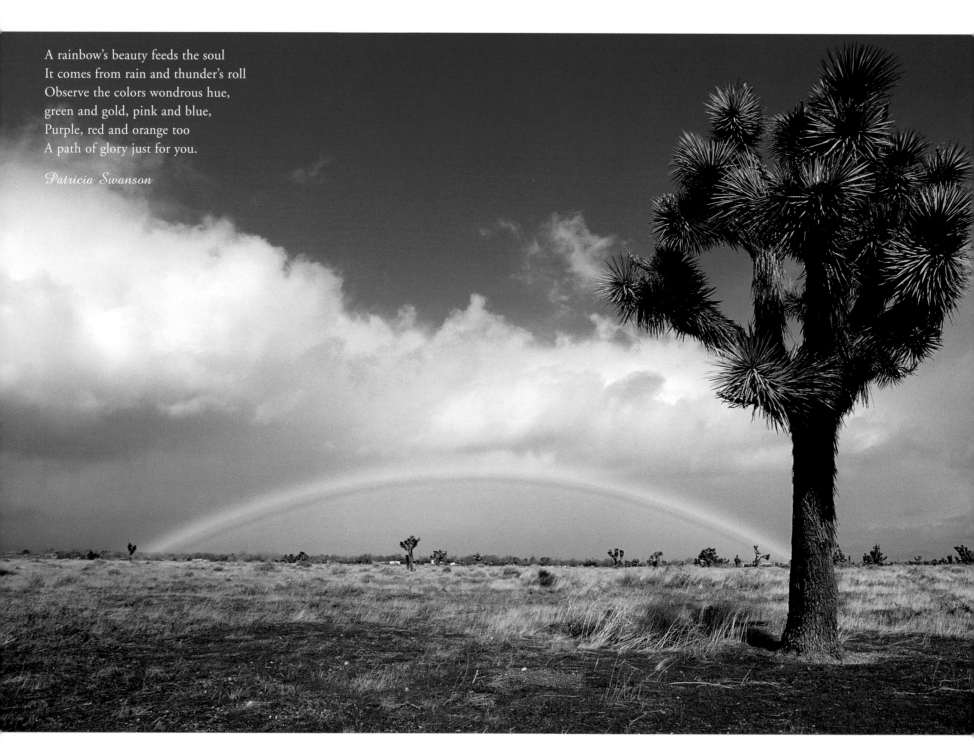

A rainbow's beauty feeds the soul
It comes from rain and thunder's roll
Observe the colors wondrous hue,
green and gold, pink and blue,
Purple, red and orange too
A path of glory just for you.

Patricia Swanson

Heaven & Earth

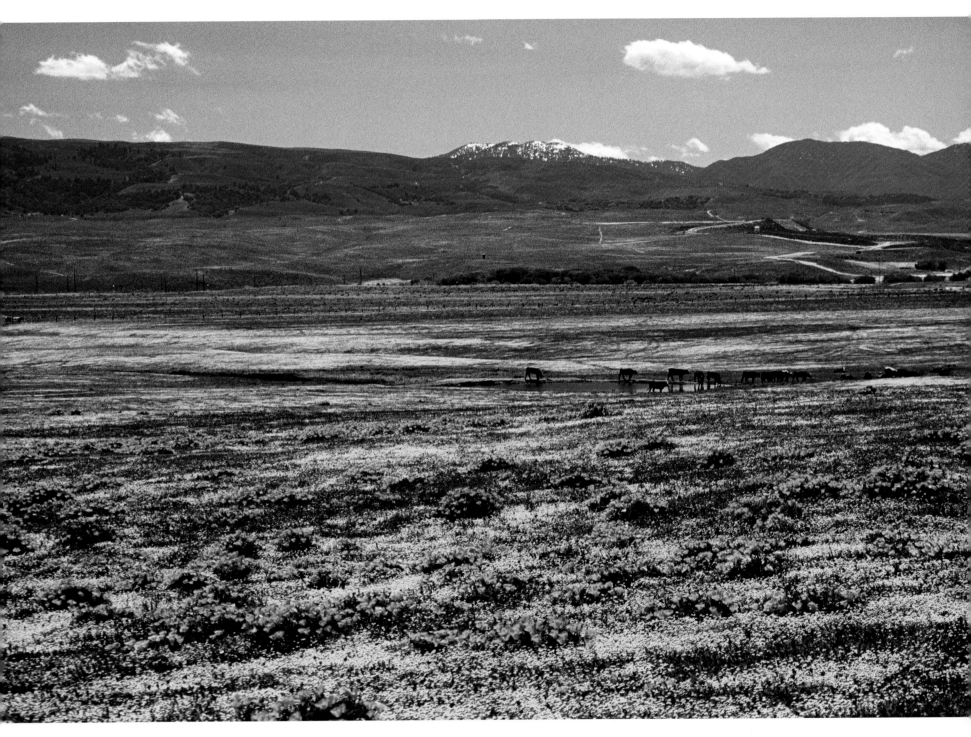

Peaceful Pasture

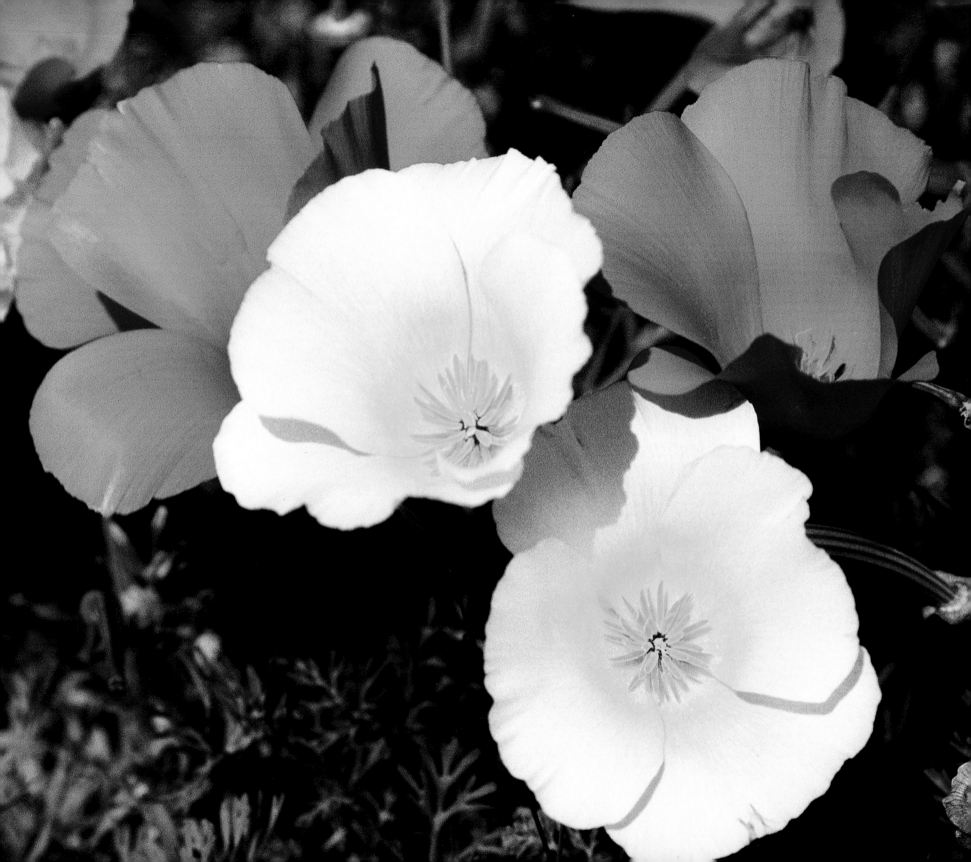

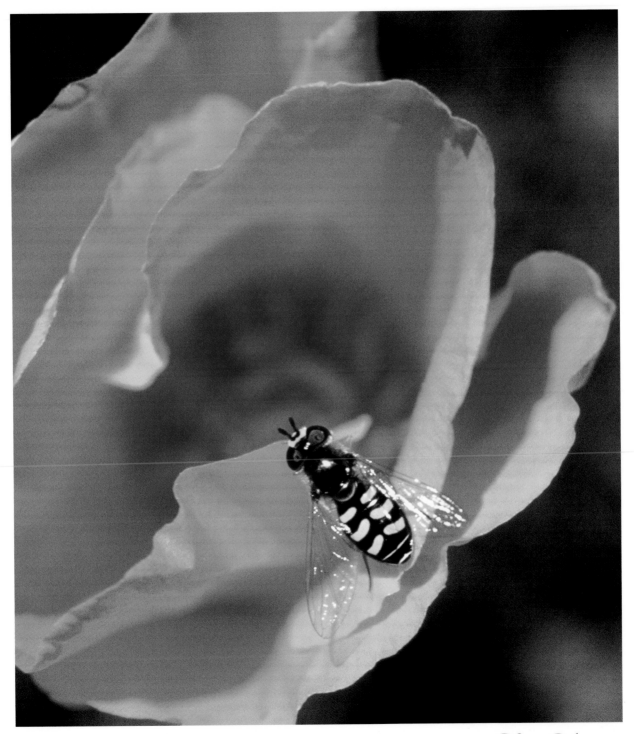

Bee Happy

Bees sing doing creative work.

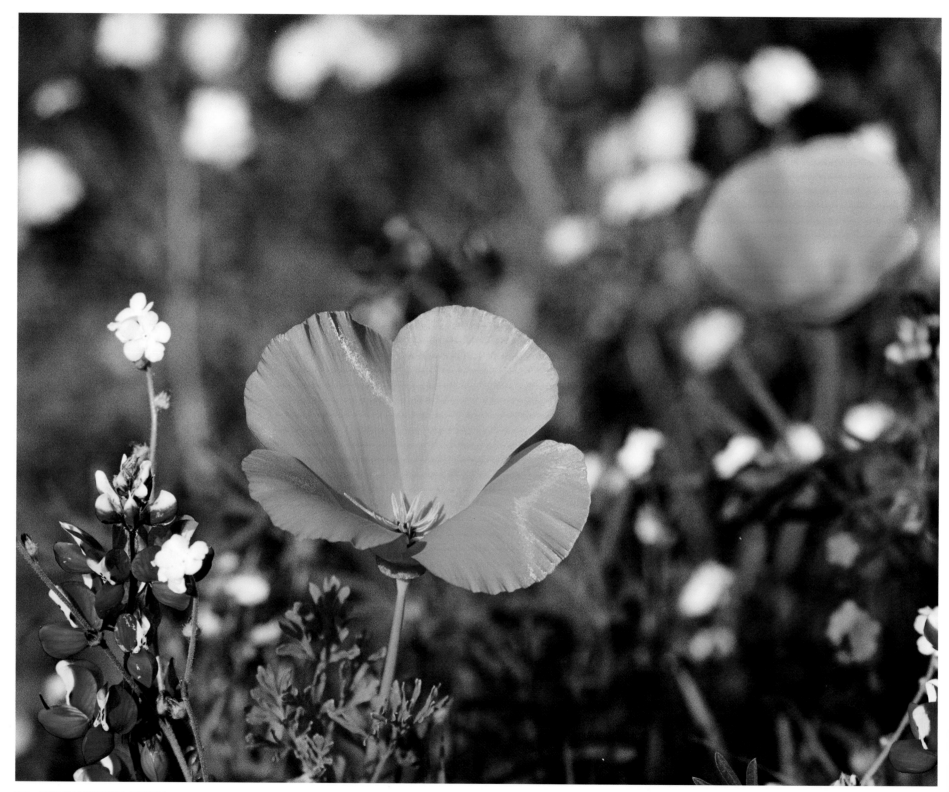

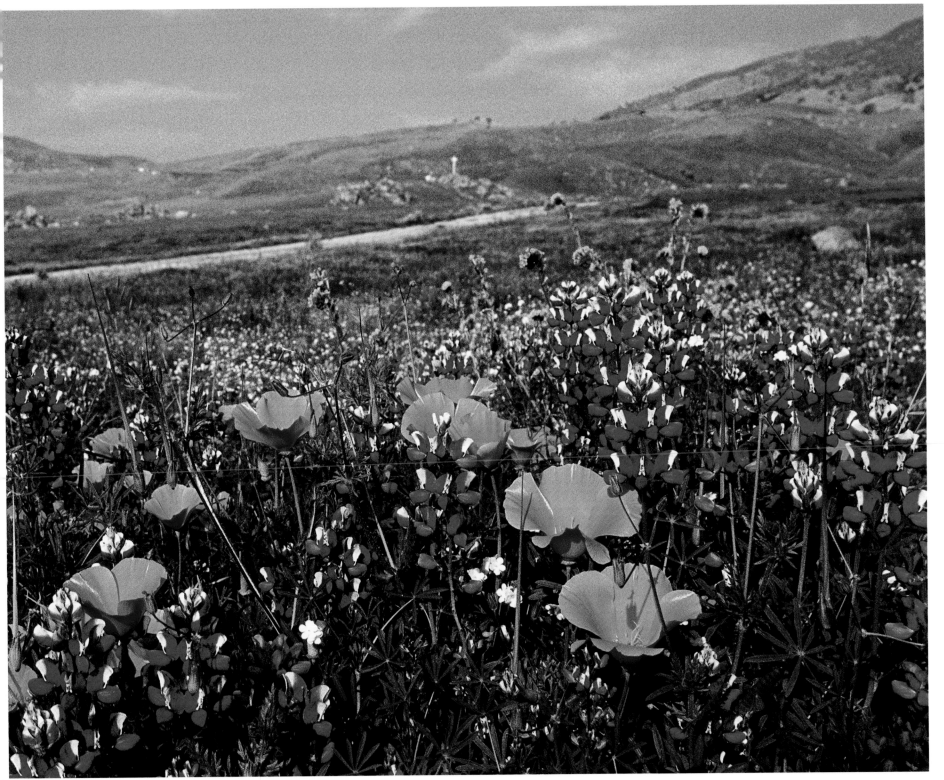

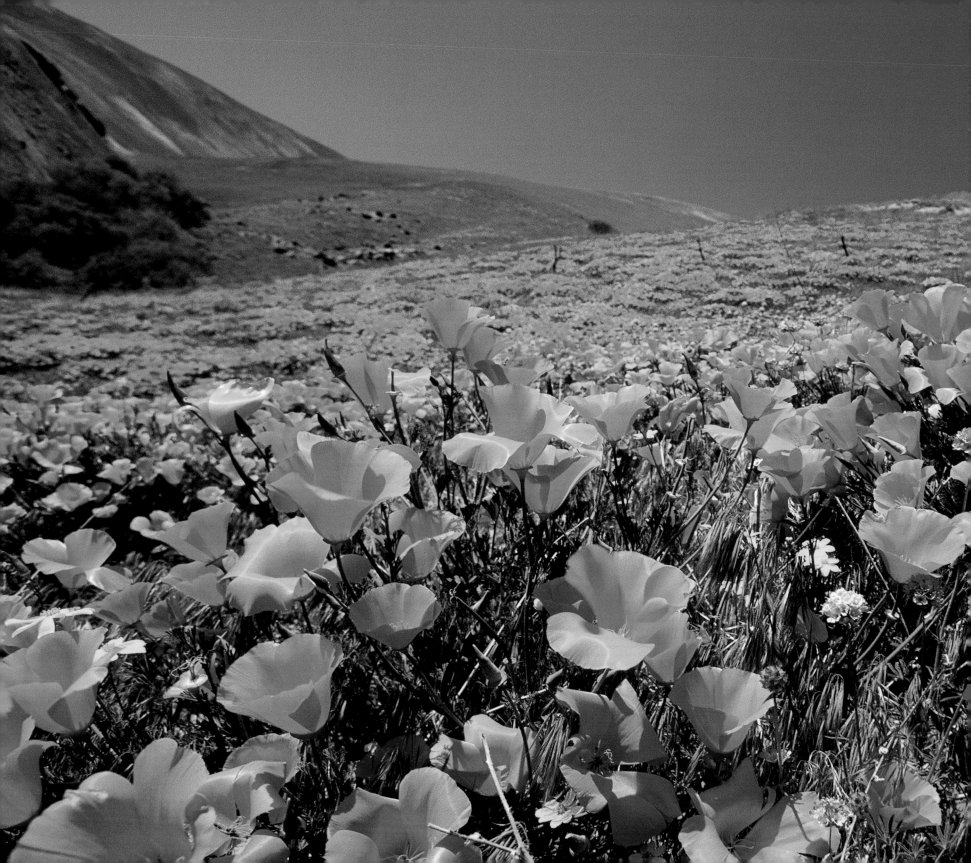

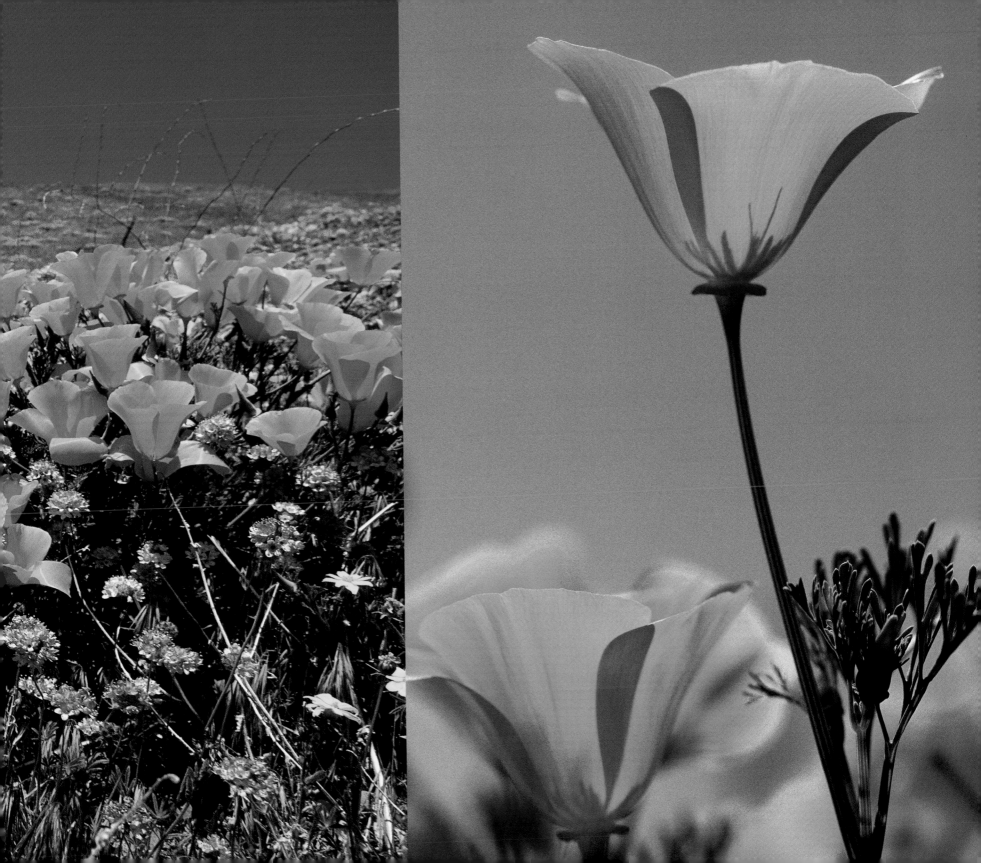

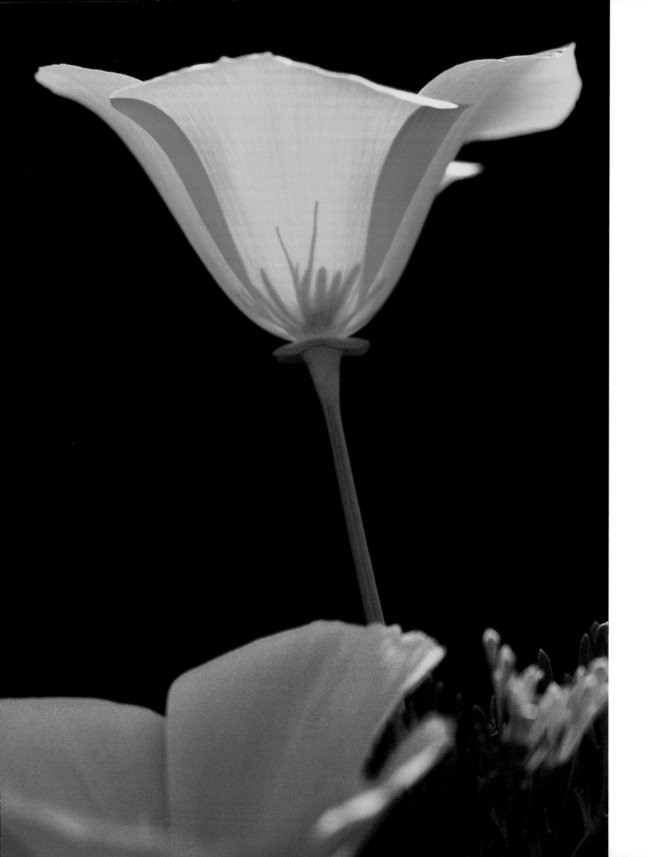

Desert Poppies

Awesome orange poppies paint the desert land
Creating soft bright blankets on Mojave's sand
Each a brilliant orange standing on its own
Adding nature's beauty as it stands alone
Desert breezes blowing toss each orange head
Defying thoughts of deserts being dry and dead
Making waves of color across each desert mile
Showing springtime beauty of poppies right in style.

Patricia Swanson

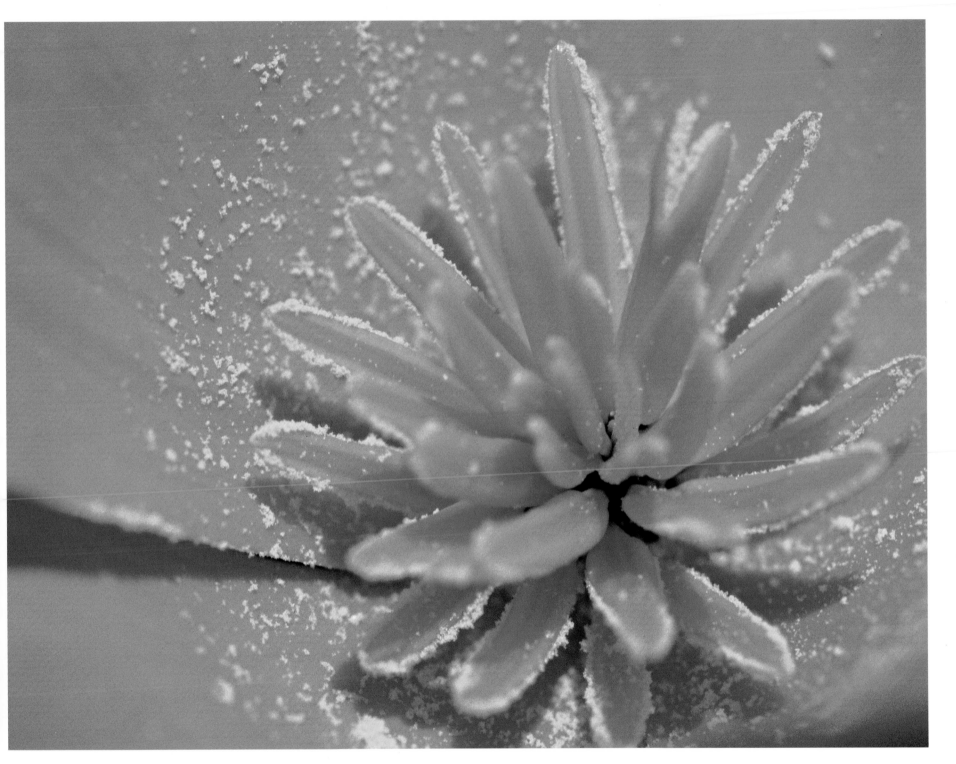

Center Spot

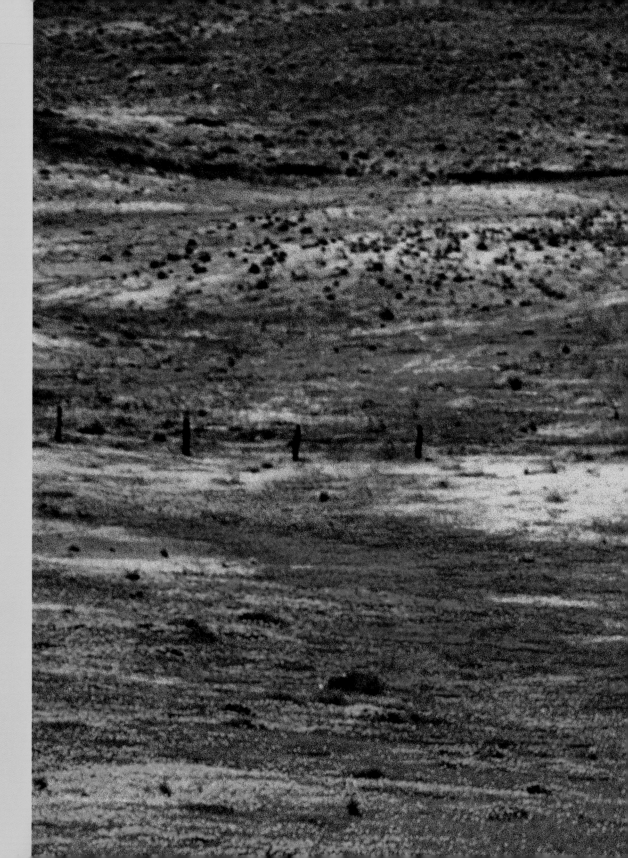

Painted Desert

Painting with flowers, a joy to behold
Painting a story that's never been told
As I stand here overseeing the land
I feel a great story, a message that's grand
It's surely a miracle sent here in Spring
A creation that only God can bring
As God works his palette and I stand at rest
I know that this picture's the ultimate best.

Kay Hendrickson

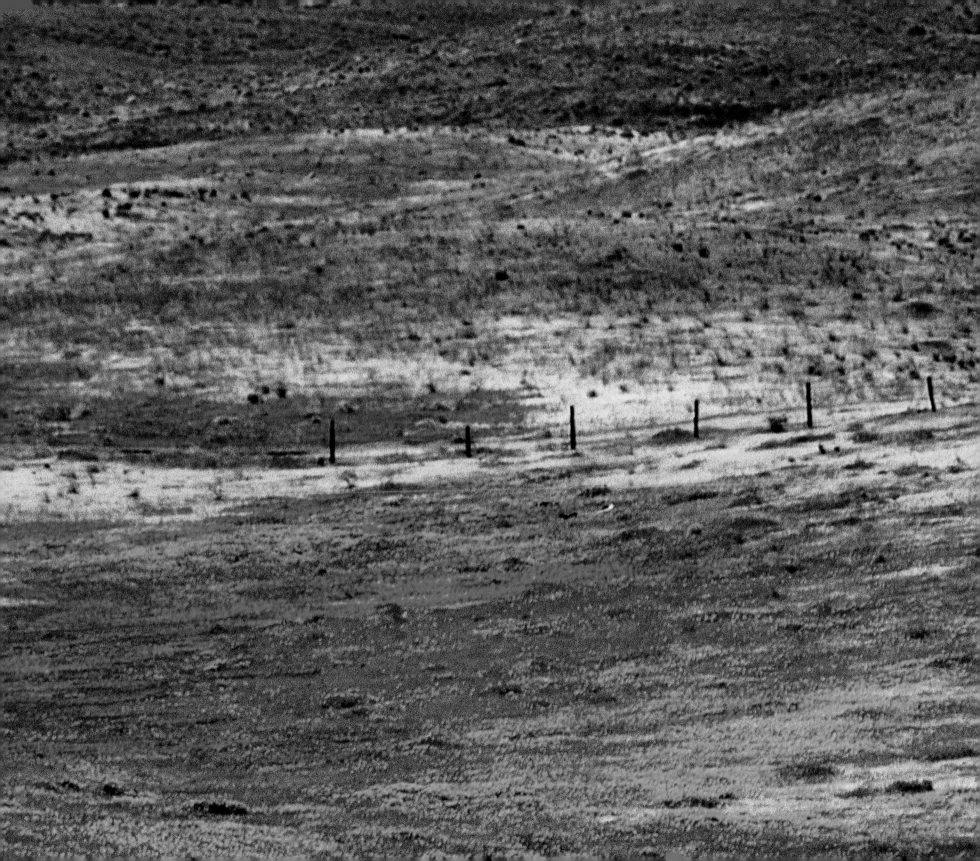

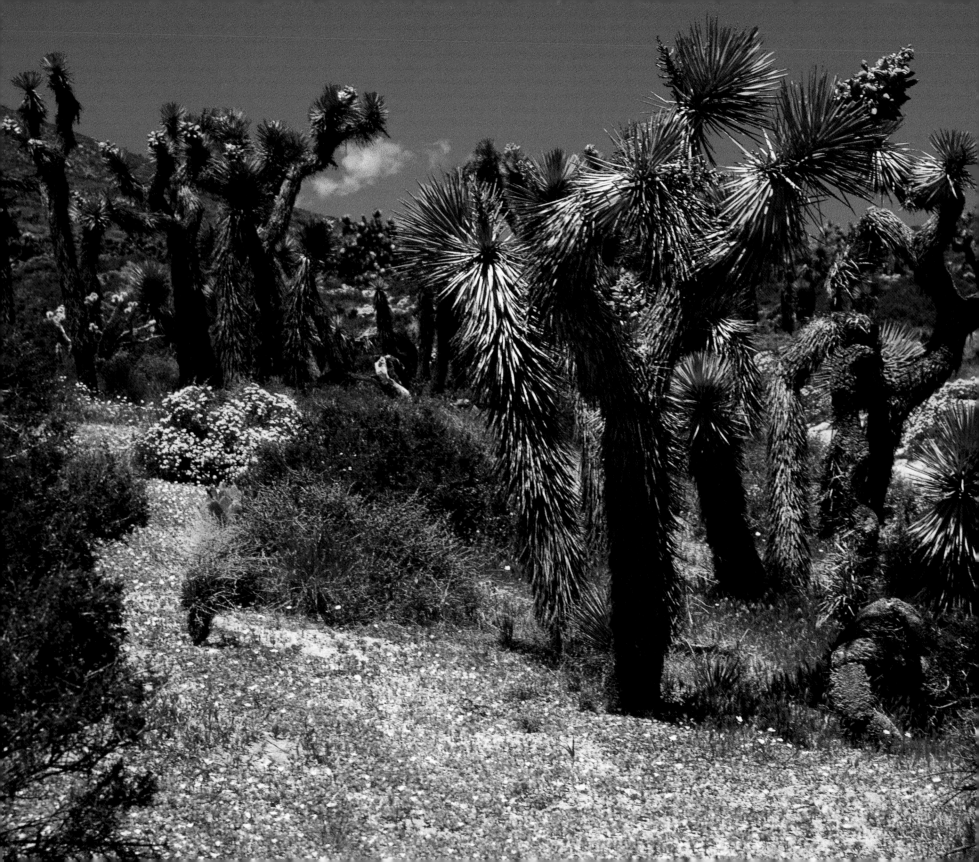

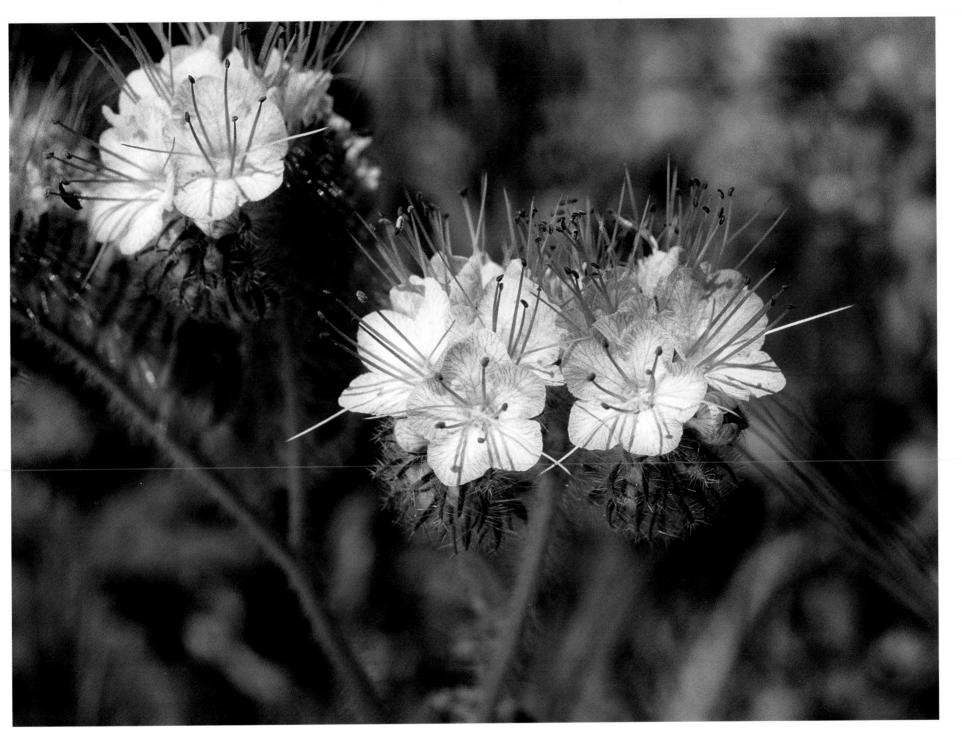

Lacey Phacilia

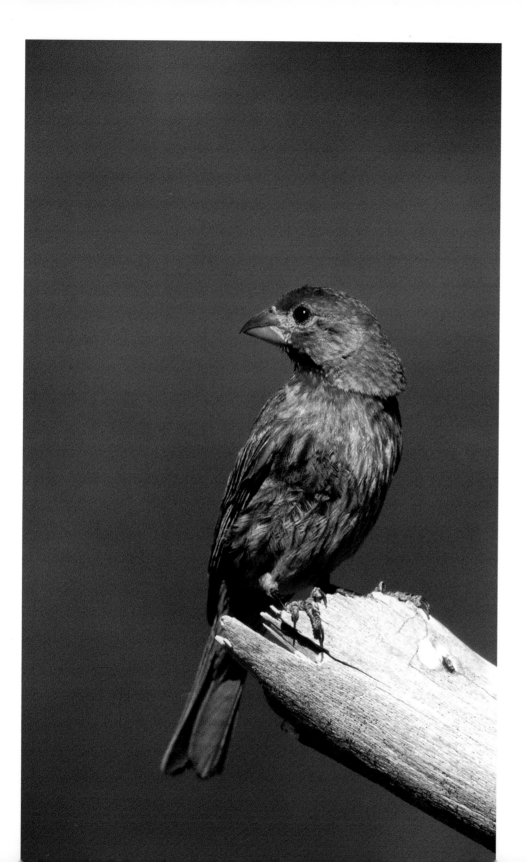

The House Finch

Let there be music to gladden your hours
Many good wishes and fresh fragrant flowers,
Memories of times when tunes filled the air
Songbirds and people sing melodies fair.
Perching on wrought iron fencing outside
This little house finch has no place to hide
Soon she will finish her rest and move on
Finding a treetop, then she'll be gone.

Patricia Swanson

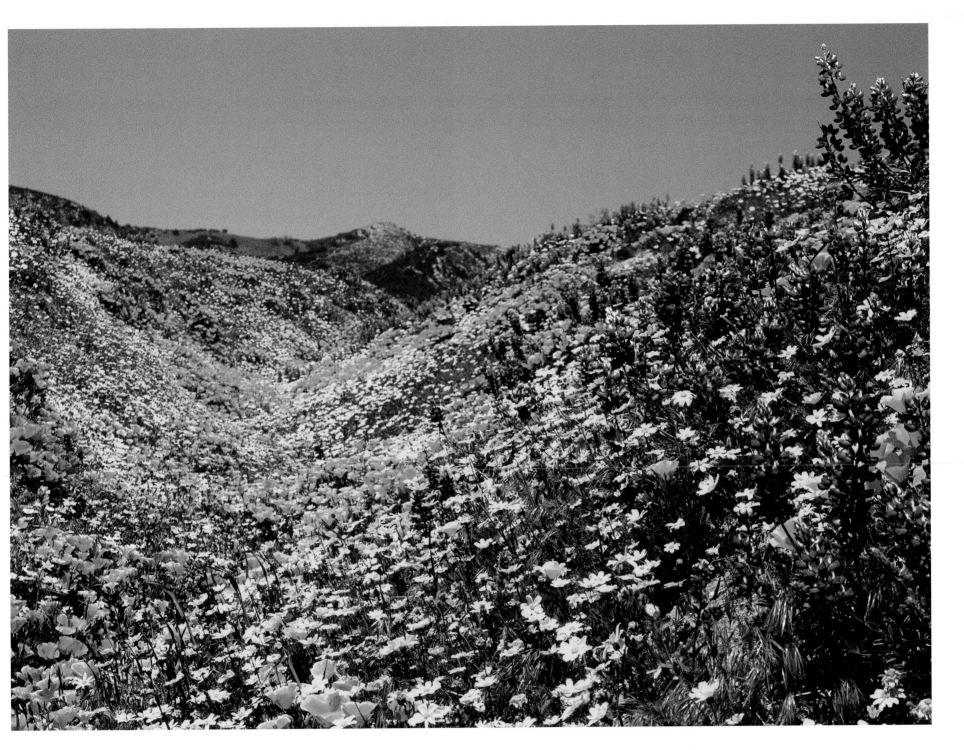

The Ravine

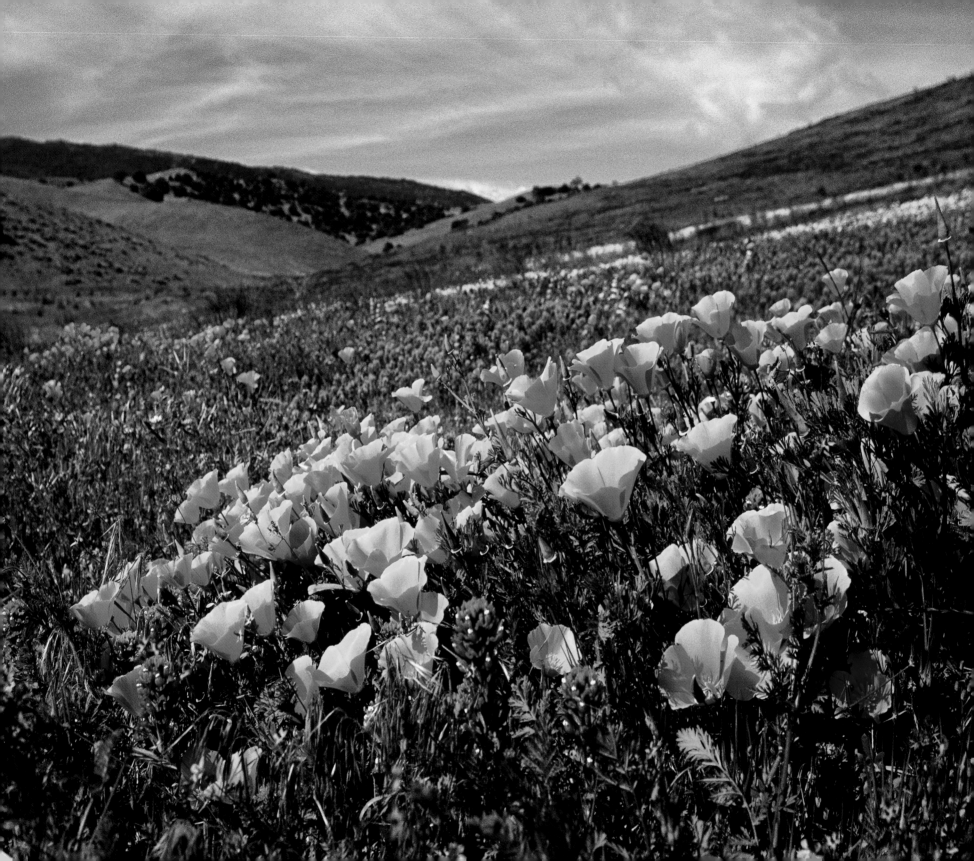

Ode to the Five Spot

Some people see the desert as a dry forbidding land, I see its awesome beauty, God's work on every hand
The glorious shining poppy ablaze around about, and if I'm really lucky see a "five spot" peeking out
Delighted is the trekker who sees this shy sweet thing, a thing of rarest beauty t'will cause your heart to sing.

Roderic MacDuff

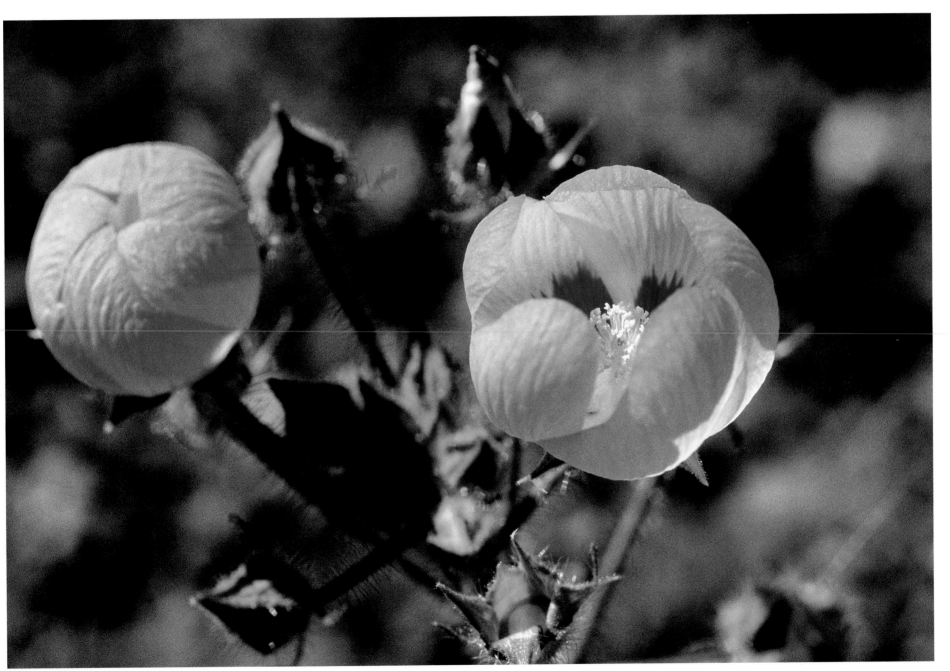

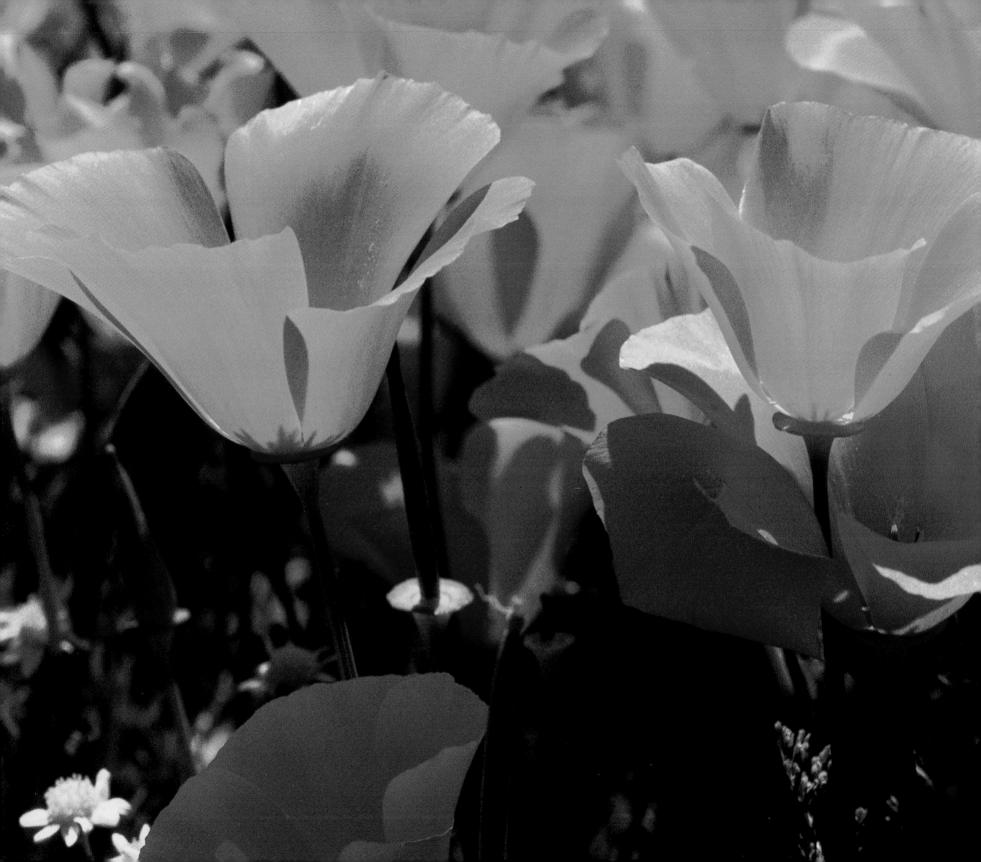

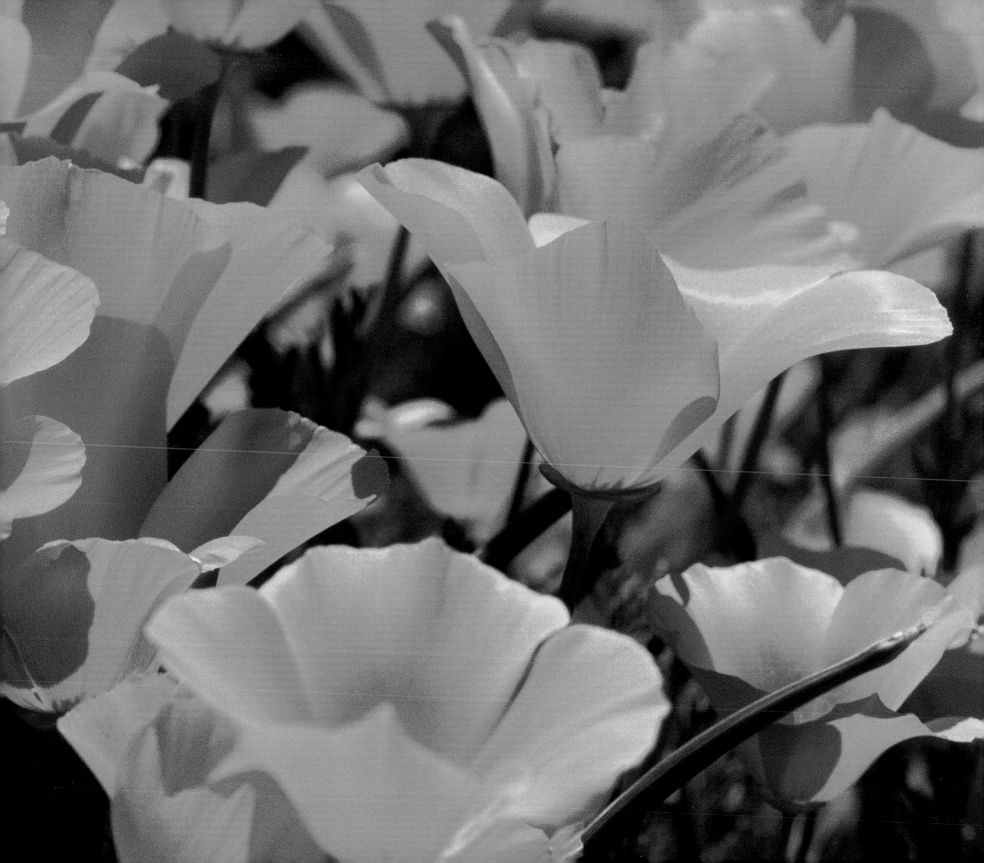

Biography

Kay Hendrickson is a freelance photographer who has loved and photographed the Antelope Valley in California for over forty years. She is well known for her wildflower photographs which have appeared on the covers of numerous publications. In addition, Kay's photography has consistently won acclaim in the *Nature and Wildflower* categories at the Antelope Valley Fair. She has also won several first place awards in the *California Poppy Festival International Wildflower Contest*. Her work has been featured at the Ansel Adams Gallery/Shop in the Sierra Nevada mountains.

Her technically proficient photographic style blends beautifully with her artistic eye to create colorful and compelling works of art. The energy and drama of her photographs are frequently used by advertisers to represent and promote the Antelope Valley.

"There is a definite thrill when Spring arrives and the new growth and rebirth of desert plants are seen. It is the natural world at its best".

Kay's hope is that her photographs will help preserve the beauty of the desert by encouraging all of us to realize that we must take action and make a conscious effort to save the environment for the enjoyment and education of future generations.

Kay Hendrickson

Acknowledgements

Clendon Hendrickson for technical support, financial planning, and his always sound advice.

My children and grandchildren who continually bring me joy.

Patricia Swanson for giving vision to my photographs through her lyrical poetry.

My publishers *Pauline and Herb Bowie*, for research, technical support and continuous encouragement.

Roderic MacDuff for his poems, *Cynthia Kline* for editing, and to both for believing in me.

A very special thanks to *Christine Kline* for her beautiful design work and for giving me the inspiration I needed to create my book.

Special thanks to *Melt Stark, Dean Webb* and all those who have dedicated their time and efforts to saving the Calfornia Poppies, Joshua Trees and the natural environment.

Jeff Strayer, Craig Becker and Greg McArthur of Ventura Printing for their guidance, generosity, and enthusiasm.